MW00714966

CITY WOMEN

CITY WOMEN

CYNTHIA SMITH

Dramaline Publications

Copyright © 1993, Dramaline Publications.

All Rights Reserved.

Printed in the United States of America.

No part of this publication may be reproduced or transmitted in any form or by any means, electronic or mechanical, including photocopy, recording, or any information storage and retrieval system now known or to be invented, without permission in writing from the publisher, except by a reviewer who wishes to quote brief passages in connection with a review written for inclusion in a magazine, newspaper, or for broadcast.

Material in this publication may be utilized for workshop, audition, and classwork purposes without royalty consideration.
If, however, the material is presented individually, or in total, before an audience where admission is charged, royalty payment is required. Contact the publisher for applicable rates.

Dramaline Publications
36-851 Palm View Road
Rancho Mirage, CA 92270
Phone 619/770-6076 Fax 619/770-4507

Library of Congress Cataloging-in-Publication Data

Smith, Cynthia (Cynthia Harrison)
 City Women / by Cynthia Smith
 p. cm.
 ISBN 0-940669-21-8 (acid-free paper) : $7.95
 1. Acting. 2. Monologues. 3. Women—Drama. 4. City and life—Drama. I. Title.
PN2080.S58 1993
812'.54—dc20 93-7411

This book is printed on 55# Glatfelter acid-free paper, a paper that meets the requirements of the American Standard of Permanence of paper for printed library material.

CONTENTS

INTRODUCTION

In this book I've attempted to present a provocative representation of characters germane to today's urban women.

You will note that age ranges have not been indicated. The reason for this is that I feel that the practice of setting age parameters is limiting and inhibiting. And, secondly, I respect the intelligence of the actress and her ability to make a proper choice in this regard.

My suggestions regarding costuming, settings, and props are strictly arbitrary and are offered only as reference. Please make your own choices and embellishments. I'm confident that they will be effective enhancements.

Good luck with these characters. I hope you will find as much pleasure in presenting them as I did in writing them. Now it's up to you to bring them to life, to get inside their skin.

CYNTHIA SMITH

JANET,
THE LITTLE WONDER

Janet runs the phones for a large investment corporation. She is wise to the guys who come into the firm. Janet doesn't take crap. Here, sitting at her phone bank, she tells of men in the workplace.

JANET

Sonsabitches come and sonsabitches go. They come, they go. In like big executive deals with their head up their butts, crawling and kissing ass and doing whatever it takes to make it. And sometimes they get lucky or brown-nose their way upstairs; but most of the time they go around sucking hind-tit and making themselves look like the little gray-flannel monkeys they really are.

I get these guys coming at me from all angles, you know. Coming at me with bullshit and demands and attitude. They come out of college and come into the company and go to Brooks Brothers and pick out their cheapest suit and come in here like big jet-set people when they're nothing but little stupid arrogant poops. They expect me to lick their wing tips. 'Cause I'm running the phones, they think I'm like their servant, or something, you know. But I put 'em in their place like real quick. Cut 'em down t' size the first day. If you don't you become crap because they'll treat you like crap if you don't throw the crap back into their faces.

This town's so full of little executive creeps. They're everywhere. Coming on and making like big and important when all they got is money for brains and a head so big it can't fit into a circus tent. That's what goes to make up the city. People on the make. On the make for fame and success. And they don't give a damn who they fuck in the process. Sad, you know. Too bad the cities are like this. Places for come-on artists and the like.

You gotta have calluses on your ego to work in this town. And I have calluses plenty. So many that sometimes I wonder whether or not they're starting to grow over my heart.

> Well then! I now do plainly see
> This busy world and I shall ne'er agree;
> The very honey of all earthly joy
> Does of all meats the soonest cloy,
> And they, methinks, deserve my pity,
> Who for it endure the stings,
> The crowd, and buzz and murmurings,
> Of this great hive, the city.
> Abraham Cowley, *The Wish*

ESTHER,
THE HERMIT

Clad in cheap sweats, Esther prepares a cup of instant coffee and speaks of the loneliness of urban living.

ESTHER

I'm only two blocks off the main drag. Just two blocks away the lights are blazing and the traffic's booming and people are on the move. Just two short blocks away. But these two short blocks are just like the distance of an ocean so far as I'm concerned. Because I'm like the loneliest person this side of forgotten.

This is the reality of being a person my age in the middle of a big city. Why, I might as well be living in the middle of South Dakota for all anyone cares. Out where your next-door neighbor is sixteen miles away. Where the wind comes whistling down the plains carrying nothing by dry grass and bad weather. The only difference is, I think, is that the guy in the next place that's sixteen miles away probably cares if his neighbors live or die.

But not here. No sir, baby. No way! Not in this unfriendly, overcrowded, crime-infested, unfeeling place. People here just don't get involved. People here are hands-off. Hell, they're afraid to get involved. Afraid if they do they're going to get ripped off, either materially, physically, or psychologically.

What you've got plenty of here is wall-to-wall fear, my friend. People afraid of people. People suspicious of people. People wanting to stay the hell away from people. The big city can be an awful lonely place. (*She sings.*) "People . . . people who fear people . . . are the loneliest people in the world. . . ."

People who want to understand democracy should spend less time in the library with Aristotle and more time on the buses and in the subway.
Simeon Strunsky, *No Mean City*

KATHY,
LOOSE ENDS

Kathy has moved to the city from a small midwestern community. She came to find excitement, experience the vitality of a big town. But so far urban life has not lived up to her expectations.

KATHY

Back in Bloomington nothing was happening. Bloomington is a very small town where, if it wasn't for the college, they'd crate the whole place up and send it to the dead-letter office. That's the reason I left. Because my life was on hold back there—at a standstill. And because, hey! the only thing I had to look forward to was working at the local mill and marrying some overweight dude who would sit around watching "Lucy" reruns for excitement. So, I moved here a little over a year ago.

At first I was stoked. High on the place, you know. I mean, there was so much happening. And after living in Bloomington all my life, every day here was like a Las Vegas night. For a while, that is, for a few months until the gilt rubbed off and the spring on the fun-clock started to unwind and the big-city halo stared turning green around the edges.

To begin with, I couldn't get a decent job. I've only got a high-school education, and back home I worked at a Seven-Eleven. So, my job prospects here were kinda limited, ya know; limited to working in like these seedy places where the people who come and go should be slithering instead of

walking. Hey, the place where I'm working now makes the Seven-Eleven back home look like Neiman-Marcus. I'm a salesperson in this place called the Love Palace. We sell what they call "marital aids." They call the stuff "marital aids" instead of what it really is, which is this far-out, strange junk for a bunch of kinky sickos, stuff that looks a lot like the tools my uncle Phil had on the wall at his Exxon station.

I think I've just about had it with the big city and the stupid Love Palace and selling creepy crawlers the latest thing in latex. Batteries not included.

She was poor but she was honest,
And her parents were the same,
Till she met a city feller,
And she lost her honest name.
Anonymous, War song [1914-1918]

HANNA,
FRIEND OF THE FREAKS

Hanna relates a story about the street characters who people her world.

HANNA

This is really strange. Last night around midnight, Little Irving—Little Irving the dwarf—Little comes over by my place with this woman named Florence who's at least twice his size. I mean we're talking huge here. Big as a tanker with arms that are extra long and seeming to drag the ground, ape-like. So, anyway, he shows up with this giant and tells me this very strange story.

He was like in the alley behind the Owl Club routing through their dumpster for maybe a discarded goodie, when he feels something weird. When he reaches in further and he realizes he's got hold of a leg, well, he jumps back. Hey, who the hell wouldn't? You get hold of a leg alluva sudden in some dumpster in some dark alley and you're gonna crap your pants purple. So he jumps back—way back. And, guess what? Florence comes up outta the dumpster dressed from head to toe in rotten food.

She says, "Hey man, like you just fucked up my nap." Imagine, sleeping like a lead pipe in the middle of a dumpster fulla garbage. So, anyway, Florence gets up and crawls out of the dumpster and stands there towering over Little Irving like a

building over a mouse, and Little Irving don't know whether to shit or go blind 'cause this woman is like this big goon with hands on her like pizza boxes. And she goes and says, "Hey, half-pint, for two cents I'd twirl you by your pecker."

Now Little Irving's no fool. No way. He may be little, but the dude's got big smarts. He can fill out a crossword and eat at the same time. A very sharp little person is Little Irving. So he says to the goon, Florence, he says, "I saw you in there and there was this rat about to crawl up your dress and I figured I'd better give you a shake before he got in a fight with your pussy." And Florence reacts very favorably to this because the thought of a rat in her snatch is very unsettling, indeed. So she thanks Little Irving and picks him up and sits him on top of the dumpster lid and they get into a deep conversation. Little Irving tells her how he's the smallest person in New York State and how he used to be with this circus before they tossed him out for getting it on with the lion-tamer's wife. Well, Florence was intrigued by this story and fascinated by the little man's grit with respect to screwing a full-sized woman. Not that this was any big deal because Little Irving never makes it with dwarfs because he says there's no challenge in making it with one of his own people.

Well, sir, one thing leads to another with Florence telling L. I.—as we call him—with her telling L. I. how she dearly loves little men because it's like this carry-over from when she was a kid when she used to make it with her teddy bear. So this puts

them on this even plane so far as sex is concerned. I mean, with the little one liking big, and the big one liking little. So Florence says, "How about us getting back in the dumpster and you showing me what you can do that that rat couldn't." Well, you don't have to invite L. I. twice into the panties department. And before you knew it, there they were locked in sexual bliss right there in the middle of three crates of discarded lettuce.

And that did it. They fell in love. Just like that. And that's why they got me up out of a sound slumber. They wanted me to marry 'em. I do weddings, you know. Even though I'm not legally ordained, I'm qualified because of my spiritual nature and my ability to look into the mystery of things. So my fellow back-alley friends have bestowed on me the honor of Vagabond Priestess.

So I married 'em and off they went just as happy as if they had good sense. Little Irving was smiling from ear to ear and Florence looked almost pretty considering she had an adequate supply of garbage in her hair.

MARY,
GUTTER DENTIST

*Mary, a self-taught dentist, tells of her trade as she ministers to
a fellow street person.*

MARY

Keep your mouth open, turkey. Okay? You go biting my
finger and I'll give it back to you in an eyeball. And quit the
moaning, for crisesakes.

You're damned lucky I happened by when I did. You got
yourself a real nice abscess here, baby. Puss city. No wonder
you got pain. An' you know what else? Your gums are a mess.
You ever have any dental hygiene when you were little? Your
mother ever tell you about brushing after meals and at
bedtime? And your breath, pal. You got breath that'd scare
Limburger. It's all I can do to stand here and give some free
dental aid to my fellow man. Quit squirming! You're moving
around like maggots on bad meat. Stop it!

You got a real bad mouthful of serious dental flaws.
Cavities, pyorrhea, loose fillings—*the works!* Hey, look, it's
one thing to live on the streets, but you still gotta pay some
attention to the choppers, hear? Next step for you is no teeth at
all. If you don't do something about this here periodontal
neglect, you're gonna wind up with less teeth than a frog.

I get me a lotta streeties who've let their chops go to hell. I
guess when you're living on garbage, you figure it's already

been chewed so you don't think there's gonna be any strain on the ivories. But this isn't the case. Just natural salts will like cause plaque to build up overnight. That's why you gotta brush off the residue in the morning. If not, after awhile you're gonna wind up with gum problems, and this means teeth that rock 'n' roll. And also, breath that ain't sociable.

I got myself into dentistry when I came across these discarded tools behind a dental clinic over on Third. When I saw 'em, I said to myself, Hey, lots of street people have tooth troubles big-time and no money for repair. So I figured I learn myself some dentistry. So I go to the library and find books on the subject with pictures of teeth in all states of rottenness. So I study and practice on like dead animals I find in the alleys. Not the best of patients, but at least they hold still for probing and don't jump around like this crazy asshole and yell, "I want my mommie, I want my mommie."

I can do most procedures. Extractions are nothing. Like just yank and you've got yourself forceps full of molar. Nothing to it. Fillings are tough 'cause I don't have the material, the gold, and the like. I have to improvise. What I've been using with real success is plaster patch and Krazy Glue. Works pretty good. Holds up until people can get to a real clinic. When there's an abscess, like this case here, I just go ahead an' yank 'em. (*Reacting to her patient's objections.*). That's right, you heard right, this baby's gotta go. (*Beat.*) Save it? Are you kidding? Save this piece of shit? This tooth is history, baby.

And you've got so much infection it's a wonder your eyes don't bleed. (*Beat.*) Okay. Okay. Then the hell with you. Go ahead and abscess to death for all I care. (*Beat.*)

That's right. You heard me right. You can't go around with infection without it eventually affecting your entire body. Hell, the way you're going, by the end of the week you'll be a regular puss machine. (*Beat.*) I'm not kidding. What I'm telling you here is medical fact. You don't get this piece a rotten enamel out of your head, you're gonna look like veal cutlet by Saturday. (*Beat.*)

Sorry, pal, novocaine's outta the question. You'll just have to grab holda your balls and squeeze till the pain takes your mind off the extraction. But don't worry, I haven't lost a patient yet. And you'll heal up in no time flat. I find a little wine as a mouthwash does wonders for the gums. Toughens 'em up in no time. So settle down here and we'll have that rotten rascal out in a jiffy. (*She leans in with forceps.*) Okay, now . . . say "Ah."

IRMA,
THE EXECUTIV'

Standing in the window of her high-rise offic..
reflects upon the aspects of power, the privileges of ..

IRMA

The city of a million opportunities. The city of hope. The city of dreams. The city of happiness and despair. And here I am up above it all. Above the corruption and the daily grind. And I love it.

I've been down there. In the streets. Down in the belly of the monster. And, let me tell you something, it *is* a monster. A monster that'll eat you alive if you're not up to the challenge of taming it. And you have to tame it, accept the realities of it, and beat it into submission. If you don't, it'll grab you by the dignity and squeeze till you're nothing but another one of the little worker ants pushing other people's loads.

I found out the hard way. At the bottom. Hell, I was below the bottom. A rube. A hick. An unsophisticated farmer who thought the city held wealth and glamour just for the moving in. I didn't realize that the city was a people-shredder, a machine, an unfeeling machine. I wasn't hip to the realities. And I paid. God, did I pay. Paid with my body and soul until I wised up to the fact that the only ones who make it are the ones who are prepared to make the big sacrifices and compromises that are necessary for success.

You don't make it to the top floor of a building like this without using and abusing and plowing under the worms. Yes, worms. Most people are, you know. They're slugs. Unimaginative slugs who drone along through life, living off the energy of others. And they complain and blame and lay their problems off on the powerful because they're not motivated enough to pull themselves up out of the muck. I can spot 'em. Hell, I can see 'em from up here. I can tell by the slope of their shoulders and their plodding walk. Their failure, their sense of resignation is written all over them. I used to have that attitude, too. Before I got wise. Before I woke up to the rules of the game.

The road to success, the kind of big success I'm talking about here, the road to success is a straight line. Don't kid yourself, there aren't any esses and curves and bypasses to the top. It's a direct route traveled by people who know exactly what they want and who are willing to make the sacrifices to achieve the goals. And if you have smarts and guts and determination, you can make it. It's a matter of single-minded devotion. Also some timing and luck and bullshit.

Do I have regrets? Yes, you're damned right I do. I regret that I failed to wise up sooner. I regret that I ever agonized over the untalented schlumps I had to crush. Schlumps who ask to be crushed, who beg to be because it justifies all their excuses for being losers.

I regret that I ever ridiculed money and power. Hell, I may have dumped on a few people, but now I'm in a position of helping thousands. Besides, people who degrade money and power are usually doing it out of resentment.

And do I feel pompous? Do I feel above others? No. And why should I? Because I'm successful? Because all successful people are corrupt—devious? More resentful propaganda from people who are waist-deep in self-pity.

The top is the only place to be. And I don't intend to live anywhere else.

I like the view.

> The perfect place for a writer is in the hideous roar of a city, with men making a new road under the window in competition with the barrel organ, and on the mat a man waiting for the rent.
> Henry Vollam Morton, *In the Steps of St. Paul*

DOROTHY,
THE TAXI DRIVER

Dot has seen it all. Let's call her one of the unshockables. Here she unloads to a fare as she drives him through the city.

DOROTHY

I've had everything happen in this cab that can happen to a person. You name it. Nothing surprises me anymore.

At first, I used to get all bent out of shape by the way people behaved and the stuff they said. This was back when. Back when I was a young thing who couldn't bake a cherry pie. (*She sings a few bars of "Billy Boy."*) That's when I was young and naive and full of fantasies and looking for a guy with a big one and a bigger bank account. Every girl's dream, right?

But, hey. After a few months on this job, all my illusions were stripped away and I saw through the bullshit for what life really is: A nutty world circus with a clown for a ringmaster.

You drive a cab for a few weeks, you come in contact with it all. It's kind of like walking through the Louvre of weirdness, you know. You get yourself a fast liberal education in human behavior. (*She swerves to miss a pedestrian.*) Holy shit! Did you see that? The fool walked right in front of the car. And did you get a good look at his eyes? Like a couple of wet Life Savers. Spaced. Whacked. These chemical-heads are all over the place.

Like I was saying before we had to dodge another common everyday freak: After driving a cab for a while, you get to see it all—hear it all. I had this guy the other day who had me drive him around while he masturbated while reading William Blake. Now is this strange, or what? And, you know, I wasn't even shocked. If this would have happened to me ten years ago back in Burlington, I would have snapped-out for sure. Like, in Burlington, public masturbation wasn't on the local agenda, you know. But here. . . . (*She chuckles at the thought.*) Here a guy could go to work with his penis sticking out and people would use it for a place to hang their donuts. Hell, nothing means anything here.

(*Stopping the taxi, turning toward her fare.*) Well, here we are. That'll be twenty-two fifty. (*A pause as she takes his money.*) Thanks. Have a nice day. (*She pulls the shift into "Drive" and pulls away.*) An interesting guy.

You know what? I'll bet nobody even notices that he's nude.

AGNES,
OF THE SHOPPING CART

She rails against the city , pushing her cart through its bowels.

AGNES

The big
The hardness of it
 Walls of it coming down
 Tumbling, falling like goddamn rain.

The people
The masses of them
 Coming at me from all directions
 Spinning, rolling like woolen-wrapped snow.

Hey, you—over there! Hear me, man? Hey, you, with the urine
stains! Hey, you, with the eyes like blisters! Hey, you, with
the feet turned to the wall! Hey, you, with the lean hands dirty
from digging for life! Hey, you! Do you hear me, man?

The night and the city
 Dark down and gritty
 With a million eyes.
 I can hear you, old town
 Hear you plain. Your—

Horns
　　Sirens
　　　　Bells
　　　　　　Shots
　　　　　　　　Screams
　　　　　　　　　　And crying.

Depressed into the doorways people are turning from themselves:
　　Wasted—jaded—and afraid.

The big-time-big-city blues. Twelve deaths to the bar. Boogie with no left hand. Swingin' in people-time to the beat of meanness and desire.

　　Let me hear them sounds,
　　Let me feel them pains,
　　Let me touch them wounds,
　　Let me heal my brother.

America! America! God shed his mess on thee. God bless you and God bless Irving Berlin.

Hammer and tongs on like the anvil of life ringing into the ghetto and the palace, and places underground where little people once big now grovel with rats and sniff the air of decay.

Homeboys on crack. Girls spread-legged and ready with no smiles. America! America! Hold on, brother. Hold on, sister. Open wide and swallow, child. Don't worry, it's going to hurt me more than it will you.

Five o'clock and all's hell! Five o'clock and all's hell!

Morning's just over the Fifth Street Garage. Sun gonna be a risin' soon. Gonna be a-risin'. And it's giving me a wake-up call.

Hello, City

Hello, Home

Hello, Desperation—

I'm giving you one more day.

DARLA,
GANG WAR WIDOW

She has seen friends, loved ones cut down in the street as a result of gang warfare.

DARLA

T' hell with the differences! T' hell with 'em! I'm sick of the divisions. I'm tired of the conflict and the hatred and the killing! Hell, the streets of this city are splattered with the blood of my brothers, with the blood of innocents—the blood of *children!* And it's on our hands. Yes it is! You're damned right it is. We're responsible, all of us, we're responsible for every goddamn drop! An' you know why? Because we perpetuate it with our stupid hatred, with our ingrained intolerance and indifference, our social blindness.

And the sadness of it is, we accept it and go on. We've accepted it, for Christ's sake. Yes, we've accepted the killing and maiming as part of our everyday life. Why, hell, the death of another brother, another innocent caught in the crossfire gets nothing more than a casual "ho hum." The killing's become matter-of-fact. Life is cheap in the city. Cheap and degraded by hatred. Why, killing anymore amounts to nothing more than a blip on our TV screens, a opportunity for the media, who love violence for the ratings it generates.

T' hell with black and white and yellow and tan and whatever. T' fucking hell with colors! Who cares? What's

important is to stop this stupid, ingrained, ridiculous hatred. Or is it too late? Is it? Is the hatred so great our differences can't be resolved by people reasoning and talking? Are we past this? Has it gone too far?

Even the most savage of animals show respect for their kind. But we, with our so-called superior intelligence, mangle each other like butchers. It's got to stop! Now! It's got to cease, I'm telling you. It must. Or heaven help us.

What you want [in Washington] is to have a city which every one who comes from Maine, Texas, Florida, Arkansas, or Oregon can admire as being something finer and more beautiful than he had ever dreamed of before; something which makes him even more proud to be an American.
James Bryce, *The Nation's Capital*

JANET,
NOT SO HAPPY HOOKER

This street-wise mama tells her story.

JEAN

Hey, came in from Dayton.
Small-town chick.
Nothing happening back in Shitsville.
People with small minds hooked up to TV in network comas.

 Saturday nights they wife-swap
 Sunday religion makes up for hell
 Monday it's back to monkey business

Worked for Harry Weinberg at Nifty Cleaners where the only thing that got cleaned were the customers. Harry Weinberg jerked off into the women's blouses. Kinky little guy with a small cock and a fat wife.

 Caught me blowing
 The steam pressman
 Fired me
 Jealous little bastard

Went and sold my real imitation watch and some burned-out jewelry to Sally Carroll, former homecoming queen who faked coming. Seventy bucks.

> Arrived cold and hungry
> Stayed cold and hungry
> Slept cheap and ate ugly
> Did my first trick in the back of a Pacer
> With a dude from Cincinnati with bad teeth
> Balls as big as Gouda cheese

Johns don't have faces. They're all the same except for degrees of bad habits. All of 'em cheap, even the rock stars. You gotta bullshit and bargain. No unions in the fucking trade.

> Straight
> Mouth
> Three-way
> Slip off your panties under the freeway

> Money first, mister
> Mister good-time small-time spender
> With a wife at home
> Sleeping in front of the
> Eleven o'clock news

Nothing shocking anymore. I've seen the bottom of the bucket and below, you know. It's business with risks 'cause you never know when some guy's nuts are in his brains.

Two black eyes
Broken jaw
Cigarette lighter burn on my titty
You get all kinds

But I'm into it good. I'm married to it for better or worse. At least I don't have to honor and obey. All I have to do is satisfy.

Straight
Mouth
Three-way
Slip off your panties under the freeway.

ELLEN,
THE STORY LADY

In a homeless shelter, the Story Lady, in her inimitable fashion, regales children with her street version of "The Three Bears."

ELLEN

Okay, like gather 'round and let the Story Lady tell you all 'bout the story of Golda Yocks and the Three Bears. (*She responds to one of the children.*) Nah. Not Goldilocks—Golda Yocks. Forget 'bout the old Three Bears story, okay? It's past-tense.

Like a few years back, there were these Three Bears who moved from the Catskills to Lower Manhattan. One was a little bear, one was a mid-sized bear, and one was like big, you know. And all the stuff they had in their apartment was little and middle-sized and big. And like they each had like these three chairs that were little, middle-sized, and big. And they had three beds like this, too. They were very heavy into little, middle-sized, and big. And, according to their neighbors, they were also little, middle-sized, and big pains in the butt.

Okay. So, one day while the bears were over in Central Park doing their business, this dried-up old comedienne, Golda Yocks, comes by their place because she'd heard the bears had brought back like this original Smith and Dale sketch from the mountains. When she looked into the windows of the bears' place and saw nobody was home, she let herself in and started

looking around for the sketch, which was titled (*With a heavy station-house-Dutch accent.*) "Dis Must Be Da Place."

She found the sketch on top of the TV and sat down to read it. But when she went to sit in the chair of the Big Bear, she couldn't because it was all full a bear doo-doo. When she went to the chair of the Middle-Sized Bear, it was crawling with fleas. So she sat in the little chair. But her big, wide butt broke the little chair down.

Looking for a nice quiet place to read the sketch, she decided to read it in bed. So she went into the bears' bedroom and crawled into the big bed. But the big bed was full of doo-doo. So she tried the middle-sized bed. But it was crawling with fleas. So she went to the little bed and crawled in and began to read the sketch. But it was so old and corny that after a while Golda Yocks fell asleep, dreaming of Shecky Green.

After the Three Bears finished doing their business in the park they returned to their house. Right away, the Little Bear said, "Hey, like some creep has ripped off the sketch." So the Three Bears started turning the place upside down searcing for it. When the Big Bear came to his chair, he said, "Hey, like somebody has left the impression of their butt in my doo-doo." When the Middle-Sized Bear came to his chair, he shouted, "Hey, like somebody has been sitting in my fleas." Then the Little Bear screamed, "Holy moly, some schnook has wrecked my frigging chair!" The Three Bears were beside themselves. Which made them Six Bears.

After pawing their way through the living room, the Three Bears went to their bedroom. Right off, the Big Bear said, "Like, wait a minute here, someone has been wallowing around in my doo-doo." And the Middle-Sized Bear shrieked, "Hey, somebody has been lying in my fleas." Then the Little Bear yelled, "Wow, like somebody has been lying in my bed and there she is, that has-been, dried-up old Golda Yocks who can't get a shot anywhere, not even at a Holiday Inn lounge." And then they all shouted in unison, "And, hey, like she's reading our sketch!"

At this, Golda Yocks woke up and said, "Take my wife, please." Then she said, "Ladies and Germs." Then, "I was walking down Seventh Avenue the other day when a tramp comes up to me and says, 'I haven't had a bite in three days.' So, I bit 'im."

The Three Bears looked at one another and then ran from the house in a panic. And Golda Yocks went back to sleep, dreaming of Henny Youngman. And that's how Golda Yocks got the sketch "Dis Must Be Da Place" for no money.

IRIS,
HOMETOWN GIRL

Iris stands in the window of her apartment looking out over the city. She turns and begins to speak fondly of the community she loves.

IRIS

In the early mornings, just before dawn, I like to walk through the city. The streets are quiet then and the air is fresh and clean. The stores and the buildings that are busy during the day are silent then and have a hushed majesty. They're . . . they're almost cathedral-like, you know. This is the best time to walk in a city. This is the best time to get to know it. This is when you can feel its history—get inside its past.

My mother and grandmother walked the streets of this city early in the morning, just like I do today. They had a love affair with it, too. It was part of them. It was in their blood, too.

When I travel, I get homesick for this old town. I miss it. With all of its problems, I miss it. Sometimes I'll wake up in the middle of the night thinking about it, and I wonder why I'm away. I think about the streets, I think about the people, I think about the buildings with their secrets. Buildings have secrets, I swear they do—they're full of them. You know, sometimes, when I'm out walking, I can actually hear them whispering, "Many things happened here. Things great and small, things

good and evil. Many things. Things we can't talk about because history has sworn us to silence."

And this city has many stories, too. One for each person who lives here. And each of these stories has a beginning, a middle, and an end. And most are never told, because they are everyday stories about lives lived—no big deal. But all of the stories are important, because they give the city its personality, they give it soul. They make it a living thing.

Moral habits, induced by public practices, are far quicker in making their way into men's private lives than the failings and faults of individuals are in infecting the city at large.

Plutarch, *Lysander*

BETH,
APARTMENT PRISONER

Standing on a street corner with a shopping bag loaded with groceries, Beth talks about the neighborhood.

BETH

You used to be able to walk around the neighborhood without having to worry about getting raped or mugged. A few years back, that is. But not today. Hell, now the streets are mean and ugly. Just the other day, Sarah Goldman was knocked down by some crazy sonofabitch over on Maple. Smashed her in the face with his elbow and grabbed her purse. You should see her. She's a mess. Her face is a swollen, blue-yellow blob. Makes you wanna scream. And she's so damned brave, too.

"Beth," she says, "the guy really did a job, didn't he? Really rearranged the territory. Gave me a whole new look."

Whole new look, all right. Sure. The look of a stepped-on eggplant. But what can I say? "Sure, honey, a whole new look," I said. "You look fine. Just keep ice on it to keep down the swelling." I really don't know what the hell ice does, but it seems anytime anyone gets hurt, they always say, "Ice it."

What the hell you gonna do? Move? Easy for you to say. Move where? To Miami Beach? The Hamptons? Beverly Hills? Hell, people in my social situation don't up and move, because wherever we move, it's gonna have to be the same kinda neighborhood because this is all we can afford. Finances

dictate. You think Barbra Streisand would move in here? Are you kidding? People with big money get lost; they're outta here. Or they buy security. Fences, locks, junkyard dogs. Mostly, though, they clear out. You have dollars, you don't live inside a meat grinder.

I watch where the hell I'm walking. Never go out at night. Are you kidding? Would be like stepping into a death camp. Hey, this city's got neighborhoods where the gangs won't even go. Remember the movie *Apocalypse Now*? Where this guy goes up this river, and the further he goes, the weirder and weirder and darker and darker it gets and the stranger the people are to the point where there's these, like, naked savages hanging from the trees? Hey, like that's this city today. Darker and darker and weirder and weirder and more threatening every day with people with eyes like wolves'.

When I'm out I don't talk to anyone. And I go fast. Never look sideways. Keep my purse under my arm. No strap. Hell, you don't ever wanna use a strap. Why? Because if you do, you could wind up like Sarah Goldman with a face like a plate of beef stew. One of these crazy people would drag you a block to get your money. You think they care?

I live alone, so I have to be extra careful. Bars on the windows. Lights all over hell. Deadbolts. I'm living like a prisoner. Hell—I *am* a prisoner. And the worst kind. Because I'm supposed to be free.

LANA,
LOOKING FOR THE BIG ON.

Sitting on a bar stool, clad in leopard spandex, Lana tells of a
recent sexual encounter.

LANA

At first they look good. Like the handsome dude the other night
at Kelley's Irish Tavern over on Third. Fantastic.

"Hey, you," he says. And I turn around and here is this
beautiful guy that's all dimples and hair. He was dazzling.
Chrome plated. Hurt yer eyes just to look at 'im. Like Sir
Galahad in boots and jeans. And there were like these little
glints coming off his teeth, just like in the fairy-tale books.
Amazing.

So, I turn around and say, real surprised like, "Me? You
talking to me?"

And he says, "Yeah, you. You an' me, okay? A couple a
drinks. How 'bout it? If you buy, that is."

If I buy, that is! Can you imagine? A guy yelling, "Hey,
you," and then having the balls to insist you buy *him* drinks.
Insulting, right? No way. This is different, I'm thinking.
Unusual. Not the same old lame thing of waiting around for
some jerk-off to slip an' slide like he's wearing margarine. This
here guy was different. Decisive. Up front. Off-the-wall. And,
besides, he is as attractive as cash money.

So I say, "Sure, why not. Yer on." Anyway, what I got t' lose? The worst that could happen is I'll be out a few dollars.

So we get drinks and move to a booth where I'm looking at an eight-by-ten glossy. And alluva sudden I'm like a little girl again with moonbeams in my panties. I was in heaven. Hell, I would have bought the glitzy sonofabitch a new suit a clothes if he'd a asked. It'd be worth it just to be up close and personal with the dimples.

Turns out the guy's a male model, okay? Did a bunch a magazine ads; even some underwear stuff for Calvin Klein. He said, "You couldn't have missed me, honey, I was the one with the bulge." I crossed my legs real quick on this one. Dimples and a bulge, too? Hey, this was heaven without dying.

So we talk. And talk. And after I buy another round, he comes over and puts 'is hand between my legs and starts rubbing very easy like. "Honey," he says, "if you want, we can go somewhere and I'll show you what made me famous in the underwear ads."

So I say, "My place is just up the street. If you don't mind walking through a neighborhood that looks like a cheeseburger somebody stepped in."

At my place, we go in the bedroom and get naked. When he takes off his shorts, out falls a garden hose. Not only does he have hair and dimples, he turns out to be a mule, too. I couldn't believe it. He looked like a handsome gasoline pump.

So we fondle and fondle and fondle and fondle. Till, after awhile, I'm all fondled out. And the guy is still limp, okay? Very big and very limp. Nothing. Was like trying to get it on with a rope. Then he says, "It takes me a while sometimes."

I say, "No hurry. Relax." Then I try all my tricks. The ones I remember from the porno tapes Doris left at the place when she was here visiting from Atlanta. Still nothing. He was a limp zucchini.

He says, "I'm sorry."

Finally I say, "Work on it yerself. I'll be in the front room memorizing all the Smiths in the telephone book. Call me when yer ready." Which he never was.

So, dimples and all, the guy turns out to be a nothing. He was a hunk of Mt. Rushmore with a good line, but he didn't have any stuffing in his pepperoni. Hell, I'd rather have Ralph. He's an ugly nerd with a weenie, but at least he can get it to stand at attention.

The big city is like a mother's knee to many who have strayed far and found the roads rough beneath their uncertain feet. At dusk they come home and sit upon the door-step.
O. Henry, *Options, Supply and Demand*

YOLANDA,
COMING AND GOING

Here she sits in the middle of the Greyhound bus station at three a.m. Looking tired and drained in the light from bright, overhead fluorescent lighting, she muses on the people passing through, evaluating their life and hers.

YOLANDA

Bus stations are interesting. Because here we're all drifters. Here we're just passing through with our bags and dreams . . . coming and going.

(*Gesturing.*) See that sailor over there? He came in about an hour ago. Just sat down hard and threw his bag down and lit up a cigarette. He had this heavy thing about him. Like he had more weight than he could carry. You could feel it in him. He was full of lead from the feet up. Some people come across like this . . . heavy in their soul.

And the woman over there in the cheap coat with the half-dead kid in her lap. They were here when I came in. The kid was crying and sobbing and her mother shook her and she cried even worse. The only words were harsh. There wasn't an ounce of love. The kid got nothing but shit. And chances are because of it she'll grow up thinking life is shit because that's how she'll feel about herself. To see her sleeping now you'd never know there was unhappiness. Unhappiness is on hold when you're sleeping.

In the ladies' room, the smell of the disinfectant takes your breath away. But the place is filthy. The floor has never felt a mop. They just spray on disinfectant in layers to cover the smell of piss and vomit. Next to me at the mirror was a woman trying to paint the sadness out of her face with cheap makeup while I was trying to cover up the miles. She said, "Where you headed?"

I told her, "Upstate. To Fresno."

She said, "Fresno? I was engaged to a guy from Fresno. He was in the army. Stationed up at Fort Ord. Went to Nam. Now his name's on the big black wall in Washington."

When I get up to Fresno, I'll get off the bus and walk through another station into a new tomorrow and hopefully a better life. Maybe up in Fresno things'll be different. Maybe up there I'll be able to get things together. Maybe, if things work out, it'll be the last bus station I'll be seeing for a while.

LINDA,
VICTIM OF THE STREETS

Confined to a wheelchair due to a gang-related shooting,
Linda speaks of the incident, venting her anger and frustration.

LINDA

You have to walk the streets like a cat, looking behind you, checking out the territory. Because the territory city is a jungle.

(*After a beat.*) So, you think I'm exaggerating, huh? Well, let me tell you, living in this place requires that a person be on the defensive twenty-four hours a day. Like I should have been the night I came out of the theater. Instead of walking along casually like I was strolling through Disneyland, I should have been on the alert and ready. But I wasn't and now here I am, half-person because of it, a piece of mangled, wheel-chaired humanity.

It was a night of hell. The gunshots came out of nowhere. Like they just suddenly lit up the night with flashes and sounds. Suddenly the air exploded into a million pieces. And all around me people were running. And there were shouts and screams. It all happened in seconds, but it seemed like a slow-motion sequence from a movie with me right in the middle of the scene.

I was in trouble, but I couldn't escape because I was surrounded. Then I felt a stinging sensation in my lower back.

Like I'd been stuck with this gigantic needle. And then I lurched and fell.

I couldn't move. I tried, but I couldn't move. I was alert, but couldn't move. I could hear and see, but I couldn't move. Then from under me I saw a red river ooze out on the pavement and in seconds my hair was floating in blood.

There were more shouts and screams and people running and people crowding around me. I tried to talk, but I couldn't. A man covered me up with his jacket and another held my hand and talked to me. "Hold on" he said, "an ambulance is coming."

In the distance I could hear sirens. Then . . . then next thing I know, I wake up with tubes connecting me to life. All around me it was sanitary white and medicinal. I was like being in the middle of an antiseptic snowstorm. And the air was muffled and still, and voices around me were hushed. A man leaned in over me. He smiled and said, "I'm Doctor Pavlatos. You're in St. Anne's Hospital. You were wounded. It's too early to make a definite diagnosis. Just relax. Just. . . . "

I began to scream. "No! Jesus Christ, no! No! No!" I knew I was in trouble because I still couldn't move. I knew right then I was a prisoner in my own body.

Two years have passed since the shooting. I was a victim of gang crossfire. And because, of it I'm paralyzed from the waist down. I've regained a bit of movement in my left foot, nothing more. This is as good as it's going to get.

Look at me. C'mon, take a good look. What you're seeing is a product of your society, a society that's gone out of control because we've lost our national soul, because we've lost all sense of right and wrong. (*With great effort she wheels herself toward her audience.*) C'mon, take a good look, take a good look. What you're seeing here is *you*!

A great city is that which has the greatest men and women.
Walt Whitman, *Song of the Broad-Axe*

KAREN,
LADY UNLUCKY

Fashionably attired, sitting in a coffee house, Karen spills her guts about relationships in the big city. Even the brightest package can be a deceptive acquisition.

KAREN

You never know about the men you get involved with in this city. There's no way of telling, not really. You think you're savvy, okay? You think you're wise, that life has given you smarts, that you've reached the point where you're able to make sound judgments. But I've come to find out there's no telling what kind of man lies under the skin. Even though all the signs seem to be right. Even though he has manners, an education, a professional position. Even though all of the elements add up to a decent, respectable person. Even with all of this, you never really know what you're getting into.

Getting involved is a crap-shoot. Because you can't judge by appearances. It doesn't mean jack. Even the prettiest package can turn out to be rotten when you take off the wrappings, when you strip away the veneer. Like Marvin. Why, on the surface he had it all: Background, bearing— position. And he was handsome. He was a woman's dream. The kind of man who gets straight-A's in *Cosmo*. On the surface he wasn't just "Mr. Right," he was "Mr. Everything."

And he was a great lover. Fantastic! And this, the fact that a guy's great in bed, is the thing you have to guard against. You can't buy into bullshit in proportion to the number of climaxes you have. This is the trap a lot of women fall into. Like I did with Marv. I made the mistake of letting him screw me into believing that he was God. Then . . . then he just screwed me— period.

Where I really blew it was letting him move in. That was a big mistake. It's *always* a big mistake. Because "in" is easy and "out" is hard. But, anyway, in he moves with his Armani wardrobe and big dick. What else could a woman ask?

At first it was cool. Fucking our brains out on the kitchen table, the sink, on top of the washer and dryer—everywhere. Hell, we would have done it on the ceiling if we could have gotten our asses to stick. And then there were the candlelight dinners, curling up in front of the fire wearing nothing but brandy, playing games . . . mostly "hide the sausage." It was beautiful. For a couple of months, that is. Till the real Marvin started to emerge from this haze of sex and self-deception. Till the real, possessive, angry Marvin started to come out of his cocoon. And he wasn't a butterfly, he was a hornet with a million hang-ups.

Slowly I began to realize that Marvin had a thing about women. He resented them. And because of it, he always had to be in control. So, little by little, he became more domineering. To the point where I was more or less a prisoner in my own

apartment. Or, should I say, *our* apartment. When they move in, *yours* becomes *ours*! Don't forget it.

It got to the point where I was afraid to do anything without his approval. Because of the way he over-reacted. Then, one night, when I told him I was going out with Janet, he came off the wall like a madman, accusing me of playing around and being unfaithful. When I tried to run out, he pinned me against the wall and started choking me. I could feel my breath going. I was becoming faint. I'll never forget the look in his eyes. Apparently he realized what the hell he was doing because he released me. I fell to the floor in a pile. The next day I moved in with Janet.

My brother and a couple of his friends went over to my place and "convinced" Marv to clear the hell out—fast. In fact, they packed the sonofabitch up and put him on the street. They must have put the fear of God in him because I haven't heard from him again.

I think I've learned my lesson. Finally. Which is: Don't put your pussy between your ears.

WILMA,
SATURDAY NIGHT DEAD

Dressed in an old robe, her hair in curlers, Wilma agonizes via a phone call over another lonely Saturday night.

WILMA

(*Into a telephone receiver.*) Doing? What do you think I'm doing? I'm sitting around, bored out of my mind. I haven't been with a man for so long I've forgotten how to fuck. I may have to refer to medical books.

I wish I had half the action you get. Well . . . maybe not. Not if they all look like Dennis and Larry, that is. I may be hard-up, but I'm not desperate. Whadaya mean, I'm too selective? What's wrong about not wanting to go out with a guy who looks like a ferret?

The last date I had was with this dentist I met in the checkout line at the market. He seemed to be okay when we were talking about the deleterious effects of poor gum maintenance, but on our date he turns out to be a cheap little creep who takes me for KFC extra crispy.

If I'd known this is what it's like here, I'd have stayed in Huntington. At least in West Virginia you *expect* it to be boring. But this is worse. Here you are, surrounded by a million men, and you wind up on Saturday night sitting around with you finger up your *TV Guide*.

No, I'm not going to go out with you and Lester and his friend, Michael. Have you ever gotten close to Michael? This guy has *Guiness Book of Records* body odor. It's lethal. If we ever decide to get into germ warfare, we can drop Michael. Wow! Does this guy ever bathe? Has he ever heard of deodorant? He's just got to work in a sewer—he couldn't hold a job anyplace else. Tell him? Why me? Let Lester tell him.

While you're out wining and dining and getting the big one, I'll be here with the Movie Channel watching John Wayne bayonet an Indian. Then I'll brew some herb tea and go to bed and study my Clairol charts. I'm thinking of becoming a flaxen blonde. Maybe this way I'll be able to attract a guy who isn't a big turkey like most of the numb-nuts in town.

Well, I gotta go. Tell Lester I said hi. And as a public service, tell him to take Michael somewhere and get his armpits disinfected.

BILLIE,
QUEEN OF WAIVER THEATERS

She sits in a disheveled dressing room in a small theater. She is removing her makeup as she tells of a recent audition.

BILLIE

So, Jimmy calls me up and goes, "Billie, baby." He always calls me "Billie, baby." Like, it's his thing. "Billie, baby," he says. "Like I got you this reading at four o'clock over at Rainbow Studios. For a falling-down-smash of a part, you hear?"

I say, "Yeah. Sure. I hear. You mean like the last great part you sent me out for? Where I go to this house way up in the hills and read for some whacked-out dork who turns out to be a producer of fuck films."

He goes, "No, Billie, baby. This is legit. These are *big* people. *Big* people, understand? This is *big* stuff we're talking here, okay? These people are connected. They do *big* pictures, understand? They got immediate access to off-shore money."

So, I go over to Rainbow like he wants, okay? And when I get there, like here are thirty other women of all sizes and shapes looking mean and eager. Actresses ain't necessarily friendly when it comes to competition, you know. In fact, they're pretty much shit-ass bitches. So, anyway, I go and sit in

a corner and study my side. Which isn't much, incidentally. To hear Jimmy tell it, it was the hottest part since *Hedda Gabler.*

After a bunch of auditions, they finally get around to me. The casting guy, some sawed-off smart-ass, he's all, "Just relax, honey, and don't try to put too much spin on the character. She's just a regular girl who's down on life because she's a junkie who has an old man who's a crack-head pimp." Like I'm thinking to myself, this is a *regular girl*?

So, long story short, I read my tits off for the squirt. After, he sits back very professional-like and tries to look four-feet tall. He then asks me to read the mess again, this time with an Arabic accent. I'm thinking, Arabic? What the fuck is it with Arabic? This is a movie about street people in Queens. And the last time I was over there, the place wasn't exactly bustling with people in sandals. Besides, my Arabic isn't exactly gonna get me the best room at the Baghdad Hilton, you know. So, I tell the squid, I go, "Like sorry, Harry, but I'm not a linguist of the desert persuasion."

He goes all, "I'd like to go for a foreign flavor."

And I go, "In that case, go blow a camel."

To say the least, this doesn't set too well with the little prick. He goes, "This is a serious picture here. *Big* budget. With unlimited money off-shore. We haven't got time for flip remarks from day players."

So, I'm history, okay? So, I leave and go back to my apartment and get loose and watch *Donohue* with married

transvestites. And the phone rings. It's Jimmy. He's like all hyped and goes, "You gotta call-back on the picture."

I go, "You gotta be jerking my wire?"

He goes, "The guy loves ya. He thinks you got balls. He wants you for the part of a dyke librarian. Perfect, he thinks. Be back there at seven. Same place. And don't screw up. Remember . . . these are *big* people with off-shore money."

So I go back and go through a thousand moods for the peter-head. Run the gamut, you know. I give him so many facets I shoulda been mounted in platinum. And he's all, "Fantastic, I love it. Now can you do it again with a Scottish brogue?"

And I go, "Yeah. And when I finish I get to ram a thistle up your ass." So, anyway, that's the reason I'm back to doing another piece of shit in another toilet. It isn't much, but at least the goddam part doesn't require an accent."

RUTH,
NIGHT VIOLENCE

A resident of the inner-city, Ruth recalls a recent riot.

RUTH

It began around midnight with shots
 Shattering
 Rapid
 Explosive

And the atmosphere was charged. You could feel it. There
was an intensity of emotion on the air. And
 Shouts
 Sirens
 Screams
 Were everywhere.

And a crowd gone wild ran past my apartment, scattering,
incensed, stampeding like cattle. It was a long and ugly night
filled with
 Fear
 Hatred
 And guilt.

From my window, I could see fire above the trees. Black
smoke unfurled in heavy plumes erasing the sky. And

television told the tale vividly, showing in close-up detail the blood and carnage.

In my own home, I felt vulnerable and alone. I was removed but I was involved, a casualty just the same. I was

A victim

A prisoner

A hostage

To senselessness.

The next morning, the streets were deserted. And stray dogs picked their way through wreckage, visiting the sites of destruction where other mongrels had preceded them. And it was quiet now. Except for the crackling of smoldering timbers. And the city felt ugly and mean, and without repentance.

At the supermarket, people whose homes were no longer habitable stood in long lines with crying children and accepted relief. Young, old—people of all ages and races blended to form a body of desolation. Outside, police in riot gear moved slowly with wary eyes.

A newscaster's voice crackled from a cheap transistor. He attempted to paint a picture of the scene with dramatic passion, pauses, and elongated vowels. But he failed to capture the essence of despair that hung over the streets.

I asked myself:

 Does anyone really care?

 Do they understand?

 Do they really give a damn?

I asked myself:

 Do I really care?

 Do I understand?

 Do I really give a damn?

But I didn't have answers. At the moment, all I knew was that I was a casualty of war.

Pandemonium, city and proud seat
Of Lucifer.
Milton, *Paradise Lost*

ALLISON,
LADY COPPER

She is cute and perky in her police uniform. She adjusts her gun, arranges her bullet-proof vest under her shirt.

ALLISON

Nobody expected me to become a copper. I mean, like, I didn't fit the mold, you know. I was the extremely sensitive type who liked ballet and art and classical music. They all had me pegged for a teacher or artist of some kind. My dad used to say, "Allison's a creative person, she has real talent. She'll probably wind up in Paris someday, living with some weirdo." He used to kid me about listening to opera. Said it sounded like people trying to sing with bad cases of bronchitis.

But I didn't know what I wanted to do. I liked the artistic side all right but—at the same time—I found an awful lot of the people in that business to be self-involved. I guess I was attracted the arts but not the artists.

When I told my dad and brothers I was going to become a cop, they couldn't believe it. They said I'd never fit, it wasn't me. Said I was too sensitive. Said after two days on the streets I'd be back to Beethoven.

At first, I have to admit, the whole scene was pretty aberrant. I mean, like they're aren't too many of us on the force. And the academy doesn't do you any favors because you're a woman. Hey, over there you're just another copper,

okay? So, the training was kind of bizarre. But I got through it. Even though, I have to admit, chin-ups aren't my long suit.

And Dad and the guys were right. The first few days on the streets were pretty unsettling. Even though I'd gone through the academy, I didn't have any idea of the wild things you encounter when you're really out there. It's just like boot camp. Basic training's one thing, the battlefield's another.

The first night we get called to a knifing over in the Hillside area. When we get there there's this woman on the ground with her cheek open from the corner of her mouth to her ear. You could put you fist in the hole. I damned near lost my dinner on the spot.

Then we get called to break into an apartment in a high-rise on 5th. The guy who lived there hadn't been seen in a week. His family suspected foul play. When we break in, the odor that hits us tells us all we need to know. He'd met with foul play, all right. He'd been murdered and robbed. It was a gruesome, unsettling scene. But I handled it, and now I'm capable of confronting almost every situation.

The only thing that still tears me up, though, is brutality towards children. In this department, I've got open nerves. When I see a child abused, used, or abandoned, I come unglued. It's one thing for some creep to go outside the law, but it's another when they involve children. Kids are innocent. Kids are pure. And they should have a shot at life. But way too often their lives are shattered by the treatment they get from

parents and guardians. You go to homes where there's blood on the walls from domestic violence and in the background is this child cowering in the shadows. And the poor kid's in this environment day after day. Think about it.

The other night we made a bust on some scum-bag who was using his daughter to do crack deals. She was eight years old, on the street working drugs. What kind of a chance does this kid have? One in a million. These, my friend, are the true tragedies.

ORDER DIRECT

MONOLOGUES THEY HAVEN'T HEARD, Karshner. Modern speeches written in the language of today. $7.95.

MORE MONOLOGUES THEY HAVEN'T HEARD, Karshner. More exciting living-language speeches. $7.95.

SCENES THEY HAVEN'T SEEN, Karshner. Modern scenes for men and women. $7.95.

FOR WOMEN, MONOLOGUES THEY HAVEN'T HEARD, Pomerance. Contemporary speeches for actresses. $7.95

MONOLOGUES FOR KIDS, Roddy. 28 wonderful speeches for boys and girls. $7.95.

MORE MONOLOGUES for KIDS, Roddy. More great speeches for boys and girls. $7.95.

SCENES FOR KIDS, Roddy. 30 scenes for girls and boys. $7.95.

MONOLOGUES FOR TEENAGERS, Karshner. Contemporary teen speeches. $7.95.

SCENES FOR TEENAGERS, Karshner. Scenes for today's teen boys and girls. $7.95.

HIGH SCHOOL MONOLOGUES THEY HAVEN'T HEARD, Karshner. Contemporary speeches for high schoolers, $7.95.

DOWN HOME, Karshner. Speeches for men and women in the language of rural America. $7.95.

MONOLOGUES FROM THE CLASSICS, ed. Karshner. Speeches from Shakespeare, Marlowe and others. An excellent collection for men and women, $7.95.

SCENES FROM THE CLASSICS, ed. Maag. Scenes from Shakespeare and others. $7.95.

SHAKESPEARE'S MONOLOGUES THEY HAVEN'T HEARD, ed. Dotterer. Lesser known speeches from The Bard. $7.95.

MONOLOGUES FROM CHEKHOV, trans. Cartwright. Modern translations from Chekhov's major plays: *Cherry Orchard, Uncle Vanya, Three Sisters, The Sea Gull.* $7.95.

MONOLOGUES FROM GEORGE BERNARD SHAW, ed. Michaels. Great speeches for men and women from the works of G.B.S. $7.95.

MONOLOGUES FROM OSCAR WILDE, ed. Michaels. The best of Wilde's urbane, dramatic writing from his greatest plays. For men and women. $7.95.

WOMAN, Susan Pomerance. Monologues for actresses. $7.95.

WORKING CLASS MONOLOGUES, Karshner. Speeches from blue collar occupations. Waitress, cleaning lady, policewoman, truck driver, miner, etc. $7.95.

MODERN SCENES FOR WOMEN, Pomerance. Scenes for today's actresses. $7.95.

MONOLOGUES FROM MOLIERE, trans. Dotterer. A definitive collection of speeches from the French Master. The first translation into English prose. $7.95.

SHAKESPEARE'S MONOLOGUES FOR WOMEN, trans. Dotterer. $7.95.

DIALECT MONOLOGUES, Karshner/Stern. 13 essential dialects applied to contemporary monologues. Book and Cassette Tape. $19.95.

YOU SAID A MOUTHFUL, Karshner. Tongue twisters galore. Great exercises for actors, singers, public speakers. Fun for everyone. $7.95.

TEENAGE MOUTH, Karshner. Modern monologues for young men and women. $7.95.

SHAKESPEARE'S LADIES, Dotterer. A second book of Shakespeare's monologues for women. With a descriptive text on acting Shakespeare. $7.95.

BETH HENLEY:MONOLOGUES FOR WOMEN, Henley.*Crimes of the Heart* and others. $7.95.

CITY WOMEN, Smith. 20 powerful, urban monologues. Great audition pieces. $7.95.

KIDS' STUFF, Roddy. 30 great audition pieces for children. $7.95.

KNAVES, KNIGHTS, and **KINGS**, Dotterer. Speeches for men from Shakespeare. $8.95.

DIALECT MONOLOUES, VOL II, Karshner/Stern. 14 more important dialects. Farsi, Afrikaans, Asian Indian, etc. Book and Cassette tape. $19.95.

RED LICORICE, Tippit. 31 great scene-monologues for preteens. $7.95.

MODERN MONOLOGUES for MODERN KIDS, Mauro. $7.95.

SPEECHES & SCENES from OSCAR'S BEST FILMS. Dotterer. $19.95.

Your check or money order (no cash or COD) plus handling charges of $2.50 for the first book, and $1.50 for each additional book. California residents add 8.25 % tax. Send your order to: Dramaline Publications, 36-851 Palm View Road, Rancho Mirage, California 92270.